ROBERT INDIANA

© 2003 Assouline Publishing for the present edition
601 West 26th Street, 18th floor
New York, NY 10001, USA
Tel.: 212 989-6810 Fax: 212 647-0005
www.assouline.com

Color separation: Gravor (Switzerland)
Printed by Grafiche Milani (Italy)

ISBN: 2 84323 525 1

ROBERT INDIANA

NATHAN KERNAN

ASSOULINE

robert Indiana's quintessentially Pop Art paintings are both signs and *de*signs—that is, formalist abstractions—and also reconcile other seemingly opposing states or impulses: stasis and motion; revelation and concealment; the abstract and the concrete; high art and populist icon; memory and what is yet to come. As signs they encode references to Indiana's personal and our collective history, while as abstractions their appeal is to the senses, with contrasting and complementary colors that flicker and delight, and forms that satisfy the eye's hunger for balance and movement.

Though a charter member of the first generation of American Pop Artists, Indiana disarmingly refers to himself as "a realist who paints real signs." As such, however, he is arguably the "purest" exponent of the Pop Art impulse. If all the Pop artists to varying degrees used the visual language of popular culture in their work, Indiana comes closest—closer even than Warhol—to taking the more radical step of, one might say, appropriating an aspect of

5

popular culture—the painted sign—as his work, and thus reintegrating it, without irony, into the very fabric of our culture. His paintings are not dependent on the fine art or gallery environment—the rarified "white cube" and the set of assumptions that go with it—for their power or interest. As signs, his paintings, not least the famous *LOVE* of 1966, speak a nearly universal language, such that, if the frames of reference of postmodern art were to vanish they would still evoke a response.

robert Clark, as he was then known, was born on September 13, 1928, in New Castle, Indiana. His parents, Earl and Carmen Clark, were hit by the Depression and moved continually from one house to another, so that by the time he was seventeen, Robert had lived in no fewer than twenty-one houses, mainly in Indianapolis. Automobiles were important in the lives of both his parents, who took special pleasure in taking car trips. Earl Clark worked for much of his life for the Phillips 66 company, whose bright red and green gas station signs, bearing the numeral "66," were a prominent feature of the Midwest landscape, and an ever-present emblem of his father for young Robert. When Robert was ten, his father deserted the family, and Carmen supported herself and her son as a cook in cafés. Robert's artistic aspirations were evident at an early age: he was "drawing and making pictures" by the age of six. After high school and a three-year stint in the Air Force, Robert enrolled in the School of the Art Institute of Chicago on the G.I. Bill, graduating in 1953 with a fellowship which allowed him to travel to the University of Edinburgh, Scotland. There he studied botany, among other subjects, and started writing poetry,

setting it in metal type and printing it by hand at the Edinburgh College of Art.

In late 1954, Clark returned to the United States and settled in New York. There he met the young Ellsworth Kelly, who helped him find a studio downtown near his own on Coenties Slip, at the time an area of abandoned nineteenth-century wharves and warehouses. Up to this point, Clark's work was figurative, with something of a religious bent, but under the influence of Kelly and other artists on the Slip, such as Jack Youngerman and Agnes Martin, Clark started painting in a style of hard-edged biomorphic abstraction. In 1958 he produced the extraordinary mural-sized *Stavrosis*, dry-brushed in ink on forty-four separate sheets of salvaged paper. Stavrosis is the Greek word for "crucifixion," and the painting is an abstract crucifixion centered on a group of circles symbolizing Christ and the Apostles. Other forms in the work were derived from Clark's study of botany, including what he calls the "avocado seed" shape and an early version of the double gingko leaf motif, which he continues to explore. It was at this time of artistic rebirth that Robert Clark changed his name to Robert Indiana.

If California is a state of mind, well, so is Indiana, an expanse of mostly flat, green farmland that lies somewhere "out there" near the middle of the United States, crisscrossed by evocatively numbered highways leading to either coast. In choosing the state of his birth and upbringing as his name, Indiana simultaneously allied himself with Renaissance artists, such as Leonardo da Vinci, also often known by their

hometowns, while adopting as his own identity a specifically American landscape, and in fact an entire culture of middle-American, "automotive" identity. It was arguably his first Pop Art act, before he had painted any Pop Art paintings, or the term had even been coined.

Continuing, by economic necessity, to use found materials, in 1959-60 Indiana made a group of paintings on 8 x 4 foot plywood panels; their subject was rows of monochrome circles, regularizing and regimenting the looser arrangement of ovoids and biomorphic forms that populated *Stavrosis*. At about the same time, Indiana also began a series—which he is still continuing—of painted upright sculptures, "Herms," using heavy wooden beams and columns (some of them formerly masts of nineteenth-century sailing ships, subsequently abandoned and used in the building of warehouses). Much of the defining imagery that was soon to appear in Indiana's first Pop paintings, including stars, circles, stenciled numbers and words, arrows, diagonal "hazard" bars, etc., was first used on the painted Herms. The beams and masts with which he made the Herms were, again, cost-free materials. They enabled the impecunious Indiana to create work of imposing physical scale at little or no expense, turning necessity into a means of discovery. For that matter, the imagery that Indiana began to use at that time, and continues to use, was also, one might say, "free for the taking," that is, generic, so much a part of the culture at large that it was overlooked.

Among the "freest" and most ubiquitous of Indiana's images is the cardinal number. Yet numbers, quantities, and sequences

hold mysterious meanings. Numbers appear in probably the majority of Indiana's paintings, and they are the exclusive subject in the sequence of "Cardinal Numbers" paintings and sculptures, which he began with *Exploding Numbers* in 1964-66. Etymologically, the English word "tell" is related to the German "Zahlen," to count, a sense that survives in our phrase bank "teller." In Robert Indiana's paintings and sculptures numbers are used to "tell" narratives, or half-tell, or recall them. The emblazoned sign or number can also be a mask, and after learning the origins and meanings of Robert Indiana's private system of numerology, it is important not to focus too much on them, but rather to absorb them and let them nourish our own original and complete response to the painting. Their meanings are not limited to those Indiana puts into them but change as soon as the painting has been made and exposed to other people, the way copper slowly oxidizes on exposure to air. Occasionally, they magically appear to grow into meanings that could not have been there when they were painted.

Of course, the materials of Indiana's "signs"—the words, letters, numbers, and symbols that are the ostensible subject of his paintings—are themselves abstractions, yet when Indiana paints or sculpts these abstractions as objects they become in a real sense concrete. Or, actually, they hover in an ambiguous state between abstraction and concreteness. Here is LOVE: we can look at it, touch it, hold it in our hands, sit on top of it, turn it upside down; here is the numeral "8": a quantity, a date, a month, perhaps, but also a specific form, bulbous, doubled, hollow-centered, infinitely

re-turning into itself. Indiana's painted words and numbers conflate two mutually exclusive modes of recognition: to read the word as a word is no longer to see it as a purely formal arrangement of line and color and shape; to see the word as formal design is to momentarily forget its meaning. The mind can never completely reconcile the two.

a t the heart of Robert Indiana's work over the past four decades has been his ongoing series of "American Dream" paintings. Retrospectively, *The First American Dream* can be seen as a kind of overture, introducing many of the themes and images that will reappear in later paintings. It also introduces a composition of four circles fit within a square that will be followed in most of the American Dream paintings. As balanced and centered and hieratic as the composition is, it retains a subtle yet all-important impulse of *im*balance, signaled verbally by the word "Tilt" (derived from pinball machines, this is a word which will often reappear in later paintings as well), and visually by formal devices such as the five-pointed stars, vertical stripes, upended squares and rings of words and numbers, all of which set up contrasting rhythms that play jazzlike against the four stolid "beats" of the base (bass) circles. Numbers in *The First American Dream* include the first five cardinals (1,2,3,4,5) arranged around a five-pointed star set within a pentagram, and also the numbers of highways important in Indiana's life, in this case 40, 29, 66, and 37, or as he wrote at the time, "Those dear and much-traveled U.S. Routes #40, #29, #37 (on which I have lived) and #66 of U.S. Air Force Days." Here, as elsewhere, Indiana's color creates light and motion with its contrasting, saturated hues set off by

blacks, which never seem to be merely black. This living, flickering trembling light, in conjunction with circular forms and precarious symmetry or partial symmetry, creates perpetual movement within stasis. Most often, Indiana uses colors straight from the tube, unmixed. They are, like his words, numbers, and symbols, "found," free for the taking, but made indubitably his own.

t*he First American Dream* was a landmark work for Indiana, and was acquired by the Museum of Modern Art in 1961, even before Indiana's first solo exhibition, which took place the following year at New York's Stable Gallery. Numerous exhibitions and museum acquisitions quickly followed, and by the mid 60s, Indiana was regularly grouped with Warhol, Lichtenstein, Johns, Oldenburg, and Rosenquist as one of the most famous and important of what were being called "new Realists" or Pop artists.

The Black Diamond American Dream #2; *The Red Diamond American Dream #3; and The Beware-Danger American Dream #4* followed in 1962 and 63, and all reprise different elements from *The First American Dream*, while adding a few of their own. In *The Black Diamond American Dream #2*, the words "Eat," "Jack," and "Juke" are introduced, and the cardinal numbers are brought up to 8. Like *The First American Dream* they employ a basic composition of four circles, inscribed with stars, words, numbers, and stripes, within a square canvas. The four circles can be related to the seed forms of the paintings of the early *Stavrosis* period, potent with latent energy and meaning. Most importantly, however, all three newer American Dreams have been tilted or rotated around their center points 45 degrees to

become equilateral diamonds, (visually) balanced precariously on one corner. They embody the word "Tilt," and their precariousness contradicts the inherent stability of the square and implies further movement—forward, perpetually turning movement.

t he fifth American Dream painting, *The Demuth American Dream #5* (1963), takes the series into another dimension. It was inspired by and based on the famous painting *I Saw the Figure 5 in Gold*, painted in 1928 (the year of Indiana's birth) by Charles Demuth, itself based upon a poem by William Carlos Williams. The poem describes the vision of the gold-painted numeral 5 on a passing firetruck, seen on a rainy day in New York. Indiana's painting retains Demuth's nested diminishing numeral 5s but places them within an orange five-pointed star, and he repeats this image, with variations, five times, on five square panels, arranged in a cruciform. Inscribed around the four stars that surround the central one are the words "Die," "Eat," "Hug," and "Err," reading like a cycle or progression, or pilgrimage of human life very briefly summarized—almost a definition of what it is to be human ("To err is human," as the saying goes). Indiana claims that he has no personal association with the number five outside of the Demuth painting. Yet as the midpoint of the series of cardinal numbers, or as the number of fingers on one hand, it holds the simple meaning of "midpoint." In 1963, when he painted *The Demuth American Dream #5*, Robert Indiana was 35 years old—at the midpoint of the Biblical lifespan of "three-score years and ten" (happily he has since exceeded that allotment). At that moment he might have recalled the opening lines of Dante's *Divine Comedy*, "Midway on the road of life..." and may have (unexclusively)

chosen Demuth, as Dante chose Virgil, as one of his artistic precursors and a guide through symbolic circles of life and spiritual growth. Indeed, Demuth, a fellow gay artist, made several paintings in the 1920s, his so-called poster portraits, which prefigure Indiana's work in significant ways—not least by being "portraits" that take the form of abstract symbols and numbers.

The Sixth Dream USA 666 was completed in 1966, just after Indiana learned of his father's death. Earl Clark not only worked for Phillips 66, he also disappeared from Robert and Carmen's lives on Route 66. The painting is unusually reductive in its palette of "cautionary" yellow and black, while the format takes the five-part cruciform of the *Fifth Dream* and tilts it 45 degrees to form an "X." Once again, the life cycle of "Eat," "Die," "Hug," and "Err" is represented. The conjunction of the words "Eat" and "Die," which were first introduced as a diptych in 1962, is of particular significance to Indiana, going back to his mother's death in 1949, when Indiana arrived home from the Air Force just in time to hear her utter the words, "Did you have something to eat?" before she died. Earl Clark, coincidentally, died unexpectedly while eating breakfast.

After a hiatus of over thirty years, the American Dream series was resumed in 1998 with *The Seventh American Dream*, painted on the occasion of the artist's retrospective at the Museum of Modern and Contemporary Art in Nice. That painting, again reverting to the composition of four circles within an upended square, pays homage to Grace Kelly and two other American women performing artists who ended their careers in France, Josephine Baker and Isadora Duncan.

With his more recent *Eighth American Dream* (2000) and *Ninth American Dream* (2001), Indiana completes the sequence. *The Eighth Dream*, and its auxiliary painting, *October is in the Wind* (2000), relate to Indiana's mother, Carmen Watters Clark, who was born in Elizabethtown, Indiana, in August (the eighth month) and died, also in August, in Columbus, Indiana. Of course, "eight" is also a homophone for the past tense of "eat," Carmen's last word.

t he magnificent *Ninth American Dream* (2001) is a kind of retrospective of Indiana's life, as well as a summary of many previously expressed texts and themes. Alone among the American Dream paintings, it contains nine circles instead of four within a considerably larger (almost 13 foot) square. Former and present homes are named: "Coenties Slip," "The Bowery," "Penobscot Bay": as Indiana has said, "All of my memories are very much connected to geography." A sense of movement pervades the work, from its precarious balance as a square tilted to form a regular diamond, to the rotating orientations of the diagonal "hazard" stripes behind the manifestations of the numeral "9" around the perimeter, to its flickering contrasting hues.

Robert Indiana's most famous work is *LOVE*, a work that has seen a great many incarnations (not all of them authorized). The primary version was executed in 1964, in vibrant red and green on a blue background, what Indiana calls "the prime *LOVE* colors" derived from the remembered sight of the red and green Phillips 66 sign against brilliant blue sky. Thus *LOVE* is on one level an homage to Earl Clark, Indiana's father, and relates to the

Sixth Dream of the same year, although it certainly transcends that specific application. In fact, Indiana has said that every single manifestation of the LOVE image is dedicated in his mind to a different specific individual.

t he LOVE image consists of the four letters of the word arranged in a square, the letters "L" and "O" on one line above the "V" and "E." Thus its composition echoes the four-part structure of the *First American Dream* and many other quadripartite works. The tilted "O," one of the defning characteristics of the work, reintroduces the notion of disequilibrium, of the "tilt," and looks like nothing so much as the forward-tilting automobile wheel in J.-H. Lartigue's classic 1912 photograph of an early racing car in motion—a picture that, with its large numeral "6" painted above the wheel, calls to mind the auto-philia of Indiana's parents, whom he depicted in 1963-67 standing at the running board of their Model T Ford. The "O" of *LOVE* is a wheel in motion, the circle that drives his work, from the parental automobile wanderlust to his non-ending texts inscribed in circles.

The first group of Love paintings was exhibited in New York at the Stable Gallery in 1966. The exhibition included not only the original, single *LOVE* emblem, but paintings in which that primary unit was doubled, quadrupled, and mirrored against itself in multiple-panel works so that the original word became scarcely legible, a pattern of lines and curves, masses and hollows.

Robert Indiana's paintings are, among other things, physical manifestations of memory, and he says, "All of my memories are very much related to geography and the houses I occupied." As if to

make up for the many displacements of his childhood, the studio-homes he has occupied in adulthood have been increasingly commodious and so stuffed with artworks, collections, and archives as to become works of art, or "Gesamt-kunstwerks" in themselves. After redevelopment drove him out of his loft on Coenties Slip in 1965, he moved to the Bowery, where he rented an entire five-floor former factory building. In 1969, visiting the island of Vinalhaven in Maine's Penobscot Bay, Indiana saw and bought one of the largest buildings there, the former Star of Hope Odd Fellow's Lodge, a gigantic Victorian structure, which he initially used as a summer retreat. In 1978 he lost his lease on the Bowery and moved to the island full time, where he maintains a second studio in a former sail loft nearby.

among the many paintings, sculptures, and prints that surround him in The Star of Hope Lodge is one of his earliest paintings, *Gingko* (1959). It depicts two stylized fan-shaped gingko leaves stem-to-stem, making a highly abstracted hourglass or figure-eight design. The gingko is sacred in China, and a common street tree in New York City, where its bright yellow leaves pave the fall streets with gold. It is the Alpha and Omega of the plant world, being among the earliest plants to survive from pre-historic times (Darwin called it a "living fossil"), and also one of the few living things to survive the atomic blast at Hiroshima. Indiana has recently made a new version of his early Gingko painting, only the new *Ginkgo* (2000) is spelled differently to allow a play on the word "Go," which is incorporated into the surrounding text, "Go from Coenties Slip thence to Vinalhaven." The text summarizes Indiana's history in

terms of "going" from one home to another, but as it's in the imperative mood, rather than the past tense, it reads more as prophecy than history. Like the place names that ring *The Ninth Dream*, it revolves in a continuous, timeless present, or state of becoming. The word "Go" might be Indiana's mantra, encompassing a circular "O" which is also a wheel and an ever-turning cycle of creativity. In the perpetual motion of his paintings, time itself is circular and constantly renewed.

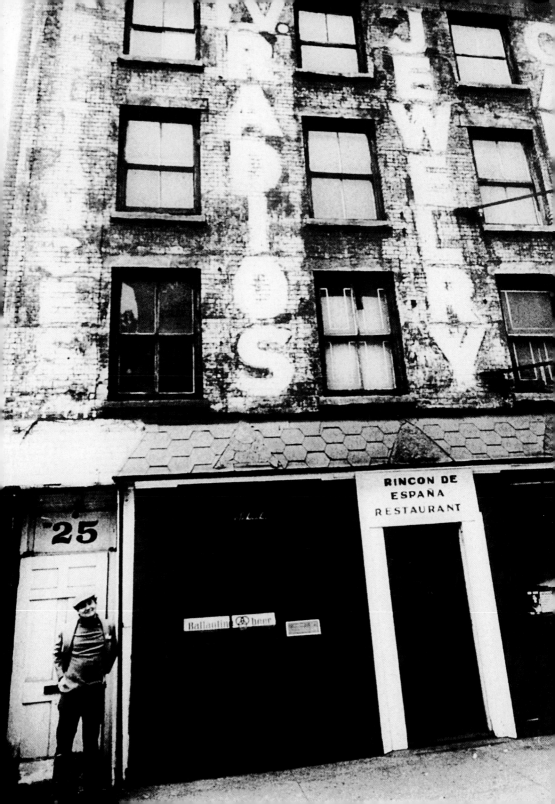

ALSO EXTEND COLOR IMPACT A.

SHELDON MEMORIAL ART MUS. LINCOLN NEBRASKA

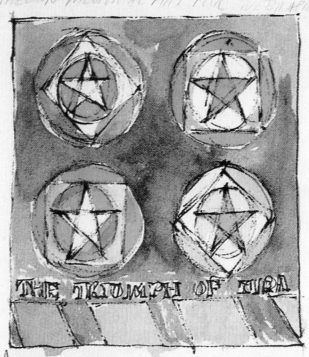

THE TRIUMPH OF TURA

ADDING MASS PEW Z. FORMERLY
BLACK, DARK YELLOW & WHITE PAINTING

· NORMAN MOWN: WATCH "NO EXIT"
AGAIN.

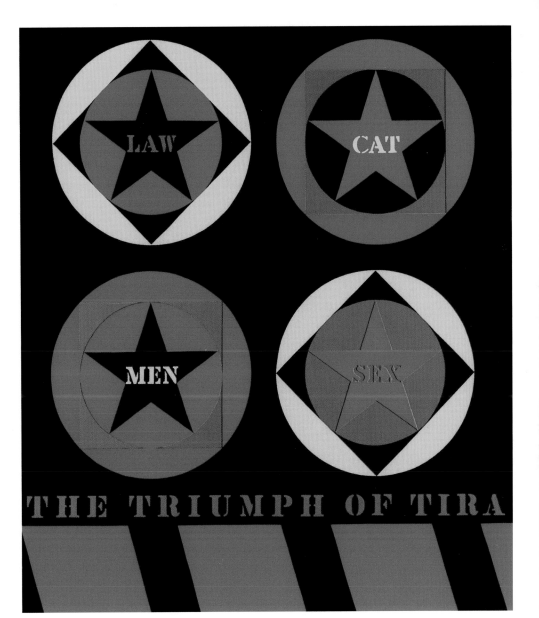

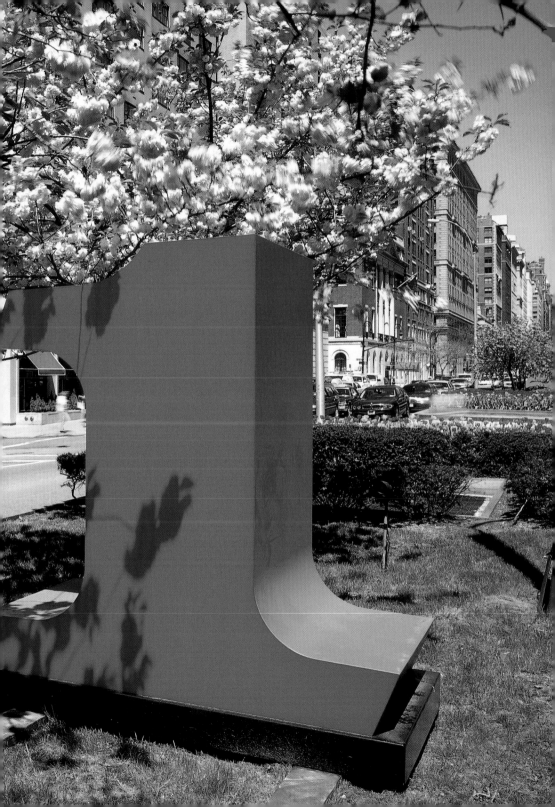

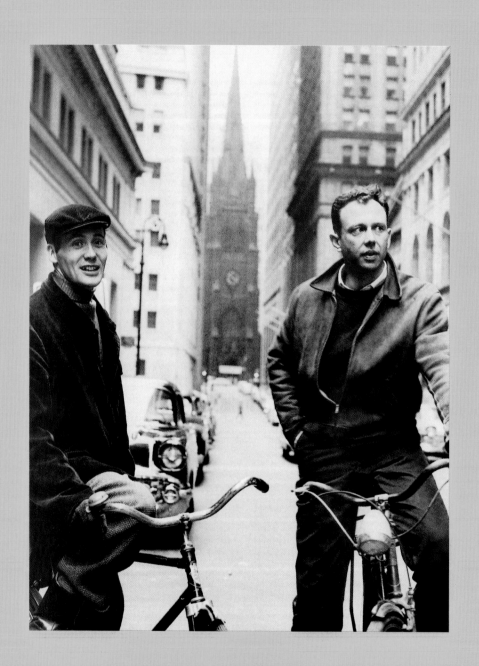

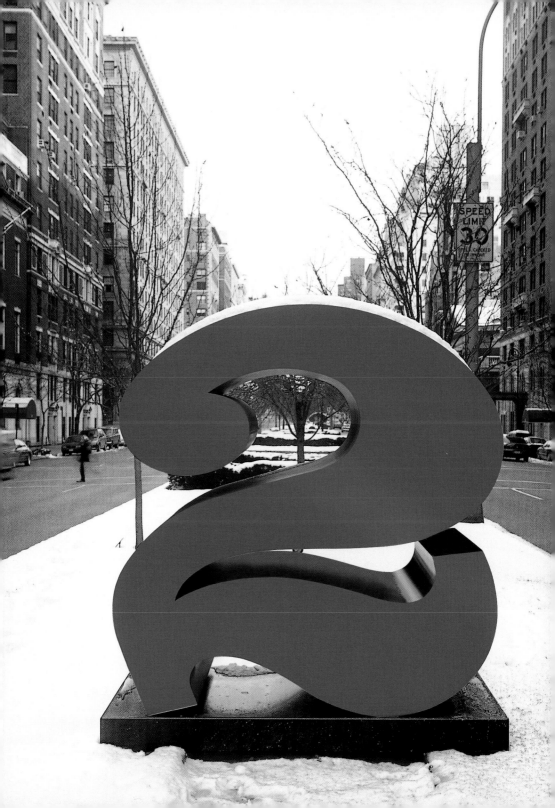

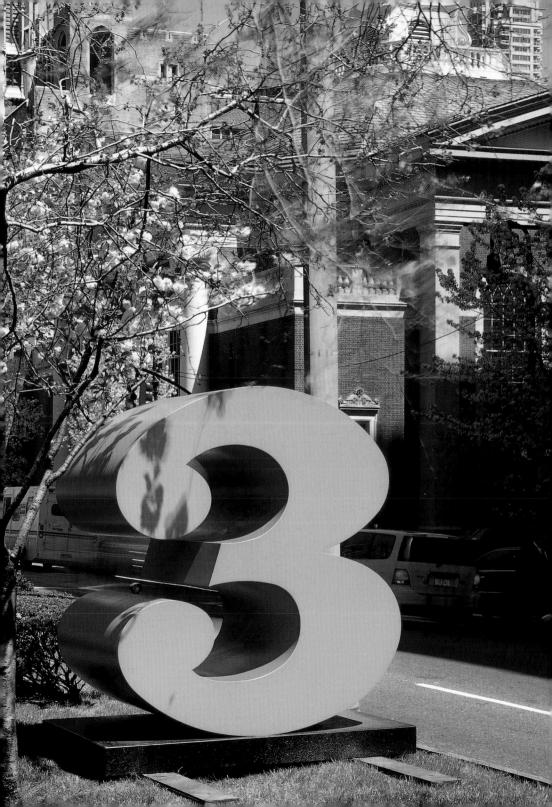

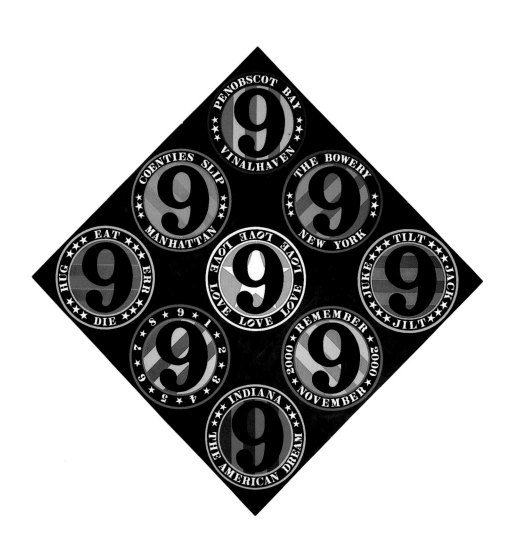

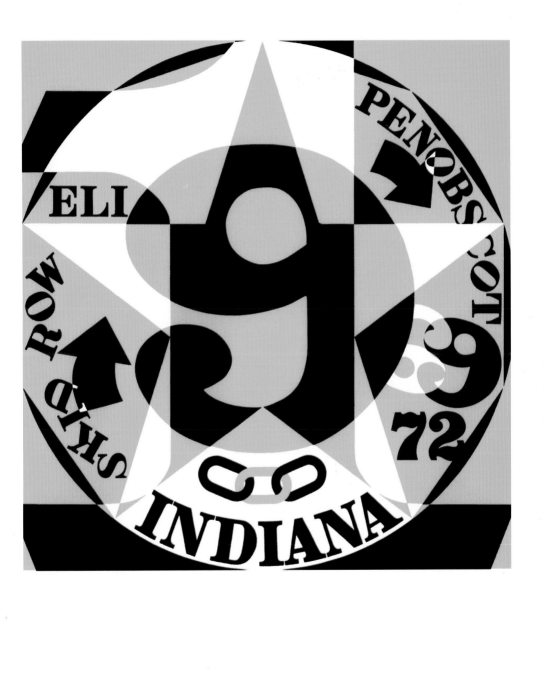

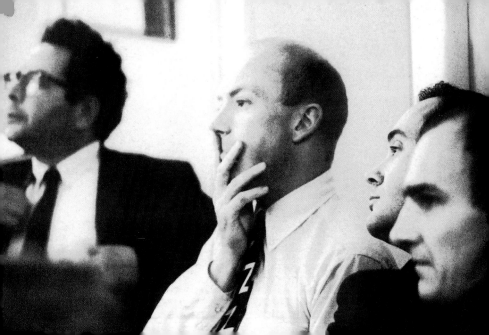

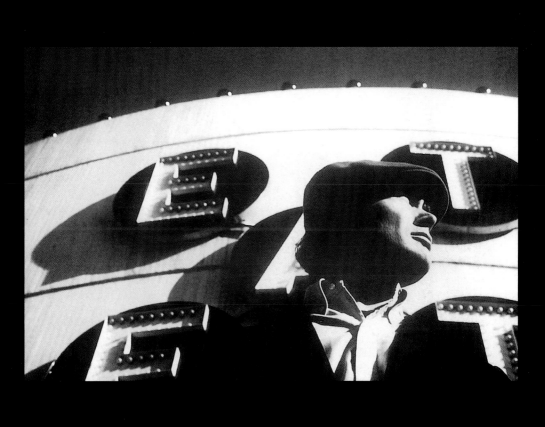

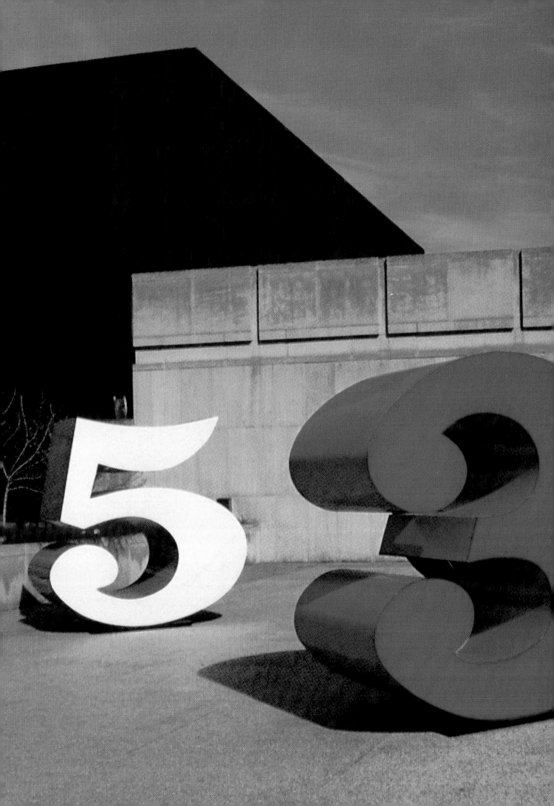

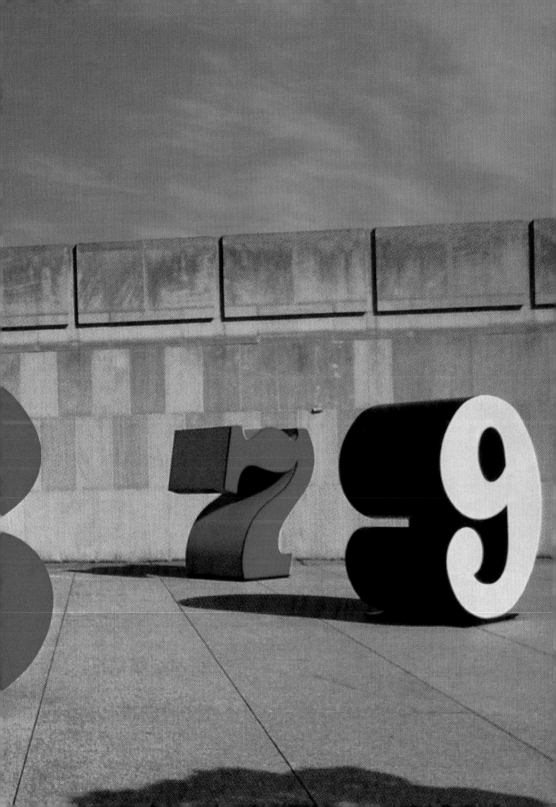

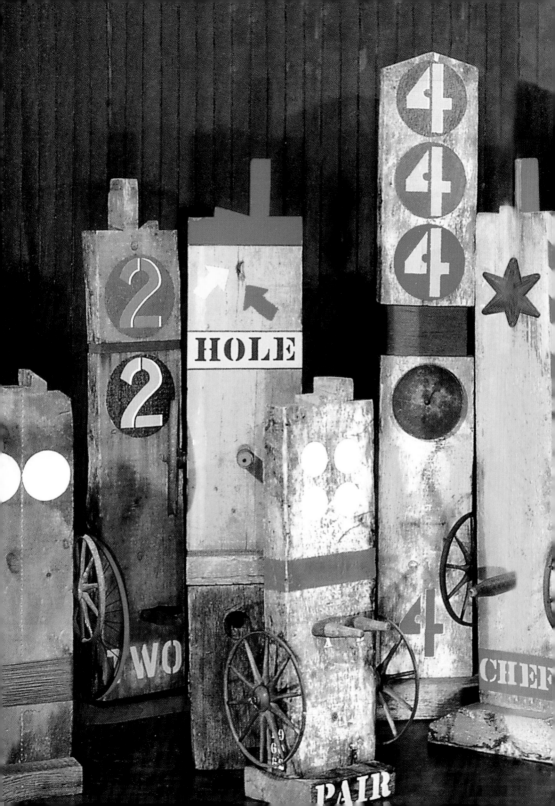

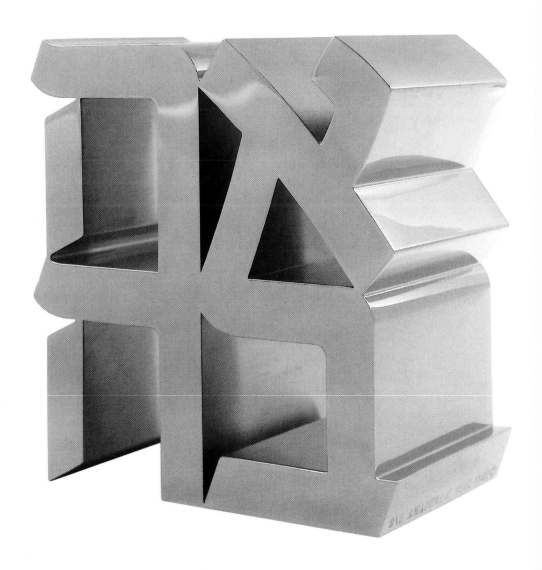

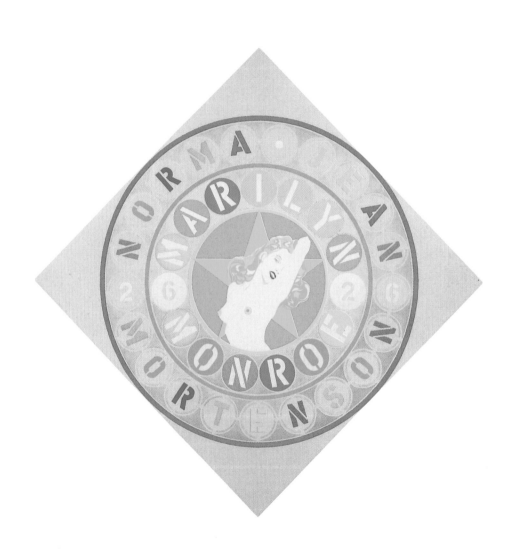

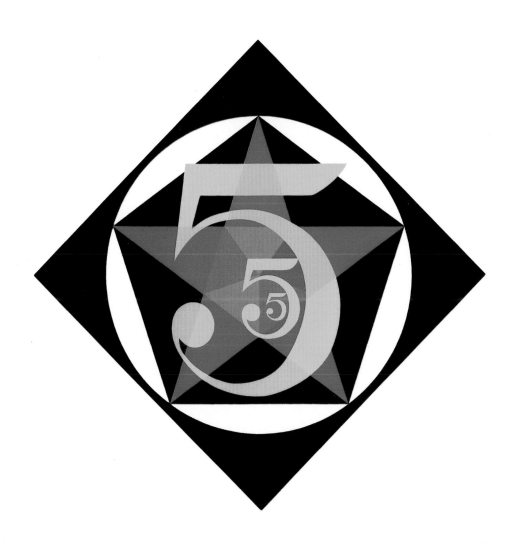

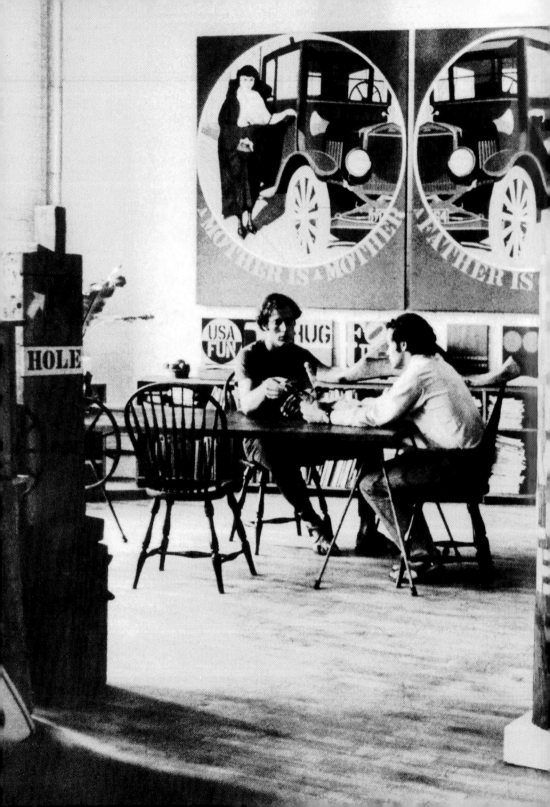

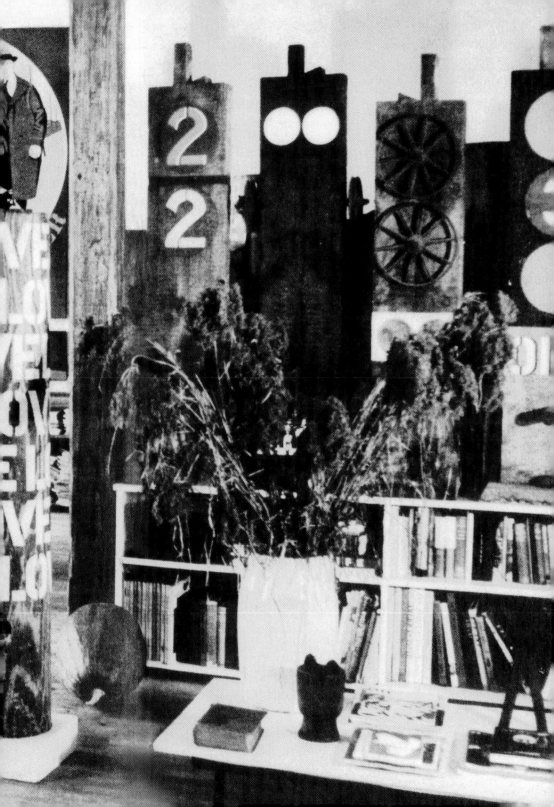

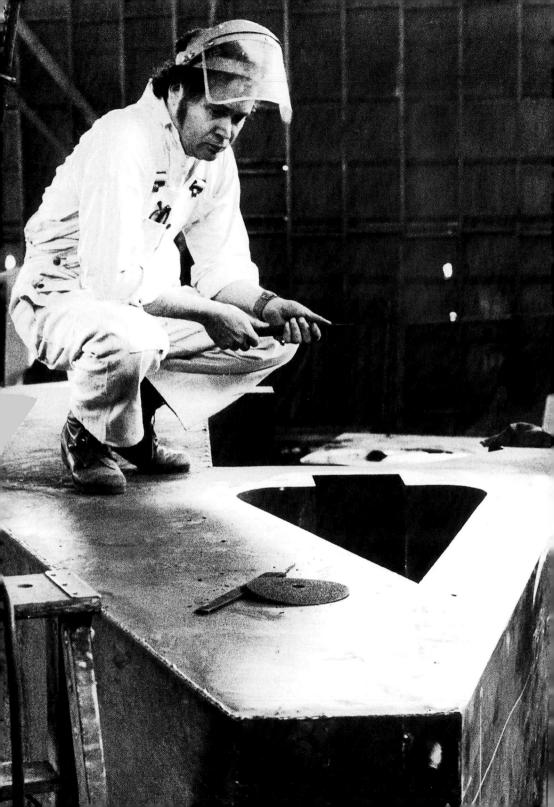

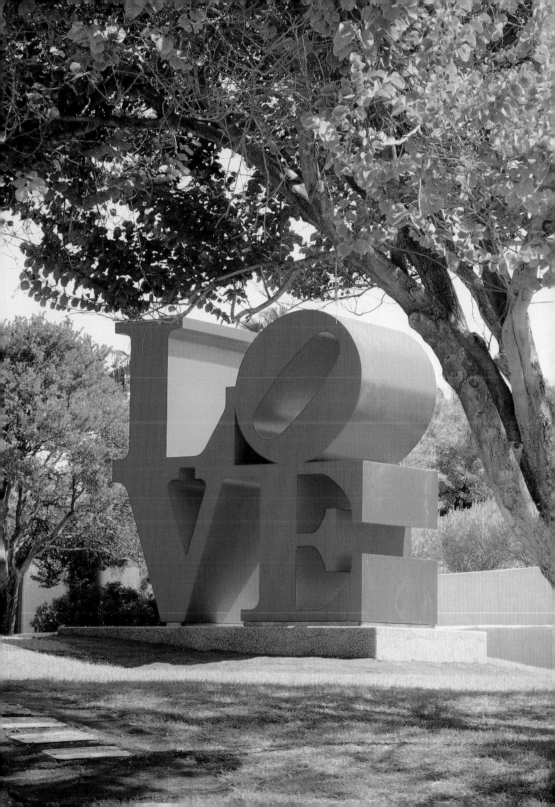

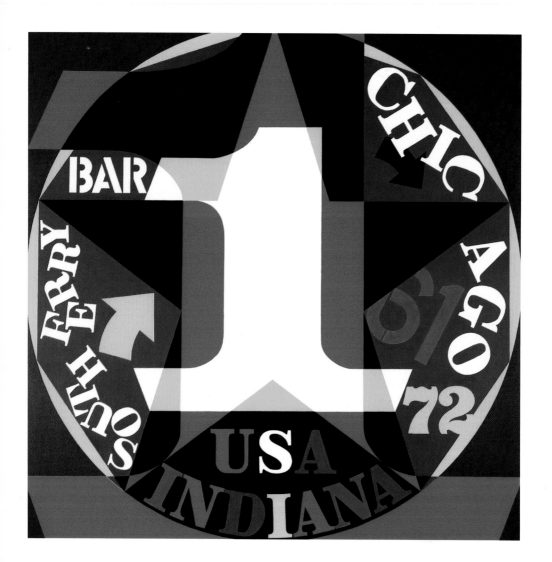

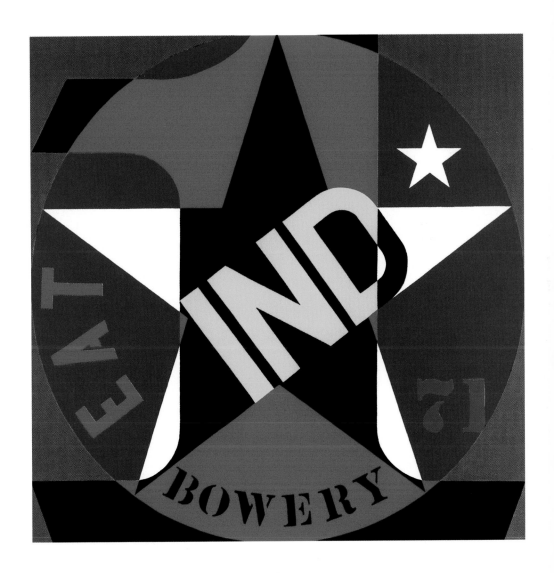

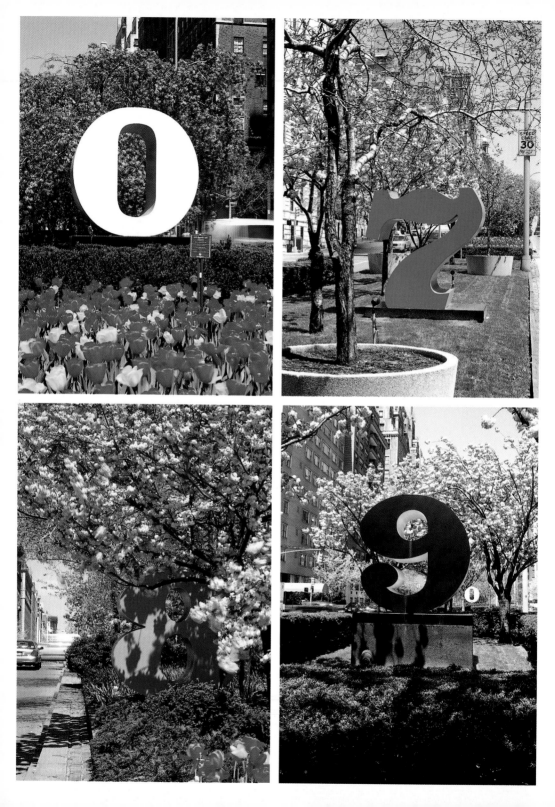

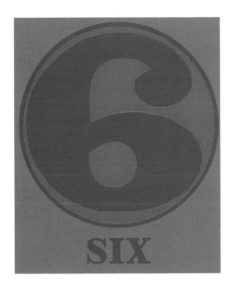

SIX

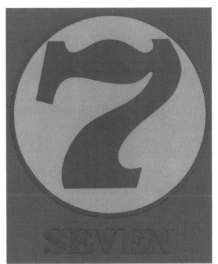

SEVEN

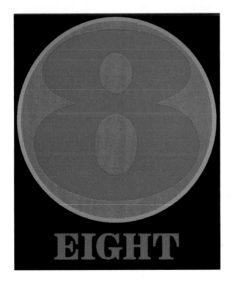

EIGHT

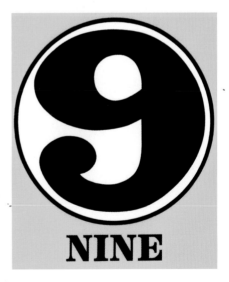

NINE

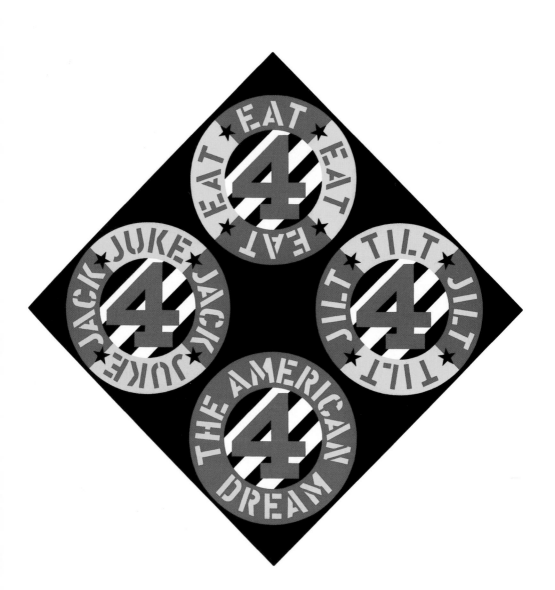

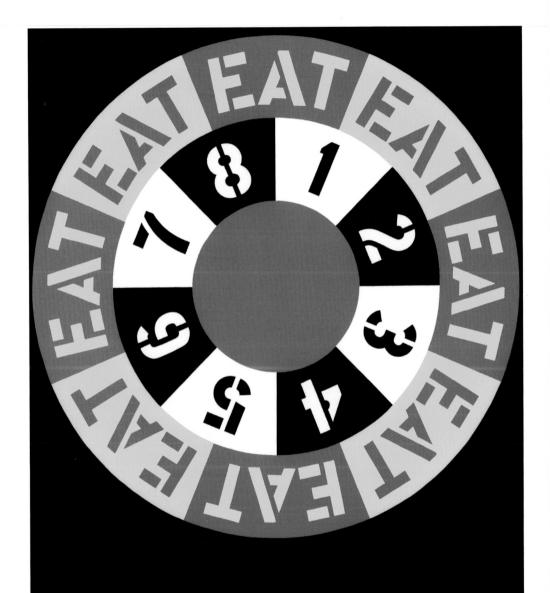

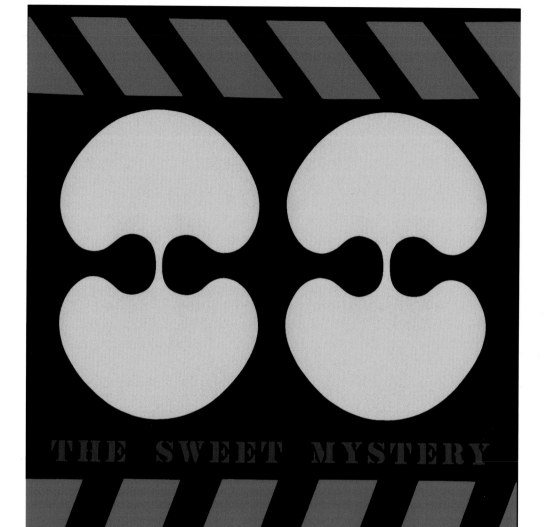

THE SWEET MYSTERY

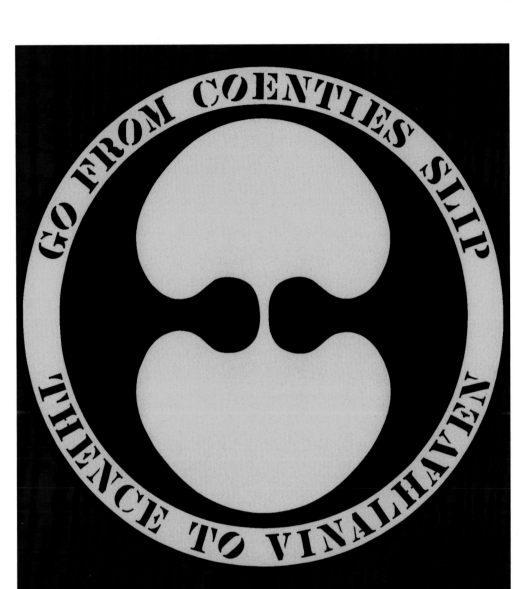

GINKGO

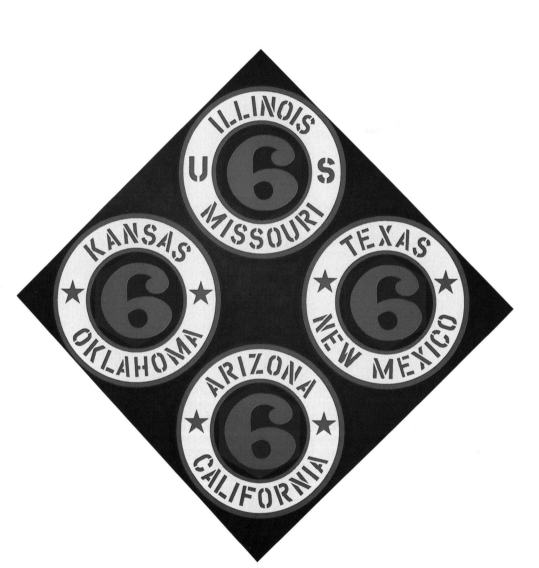

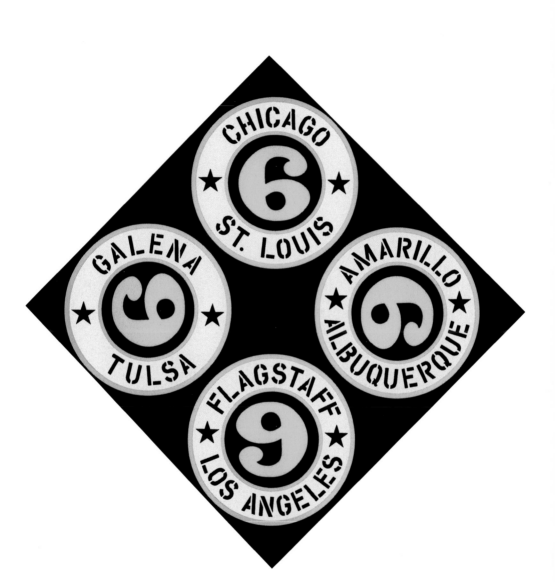

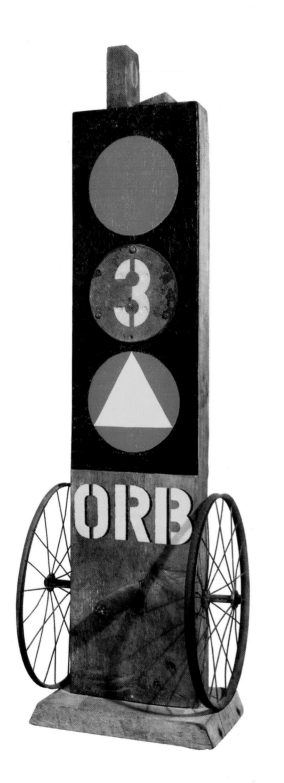

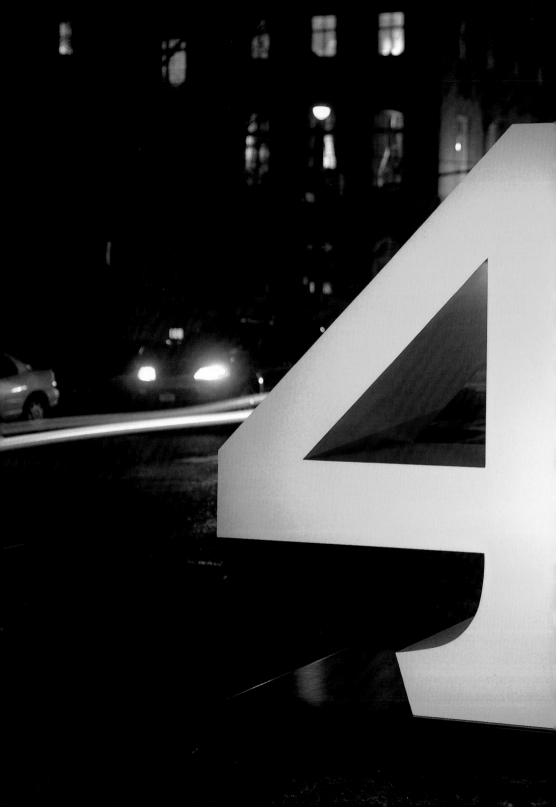

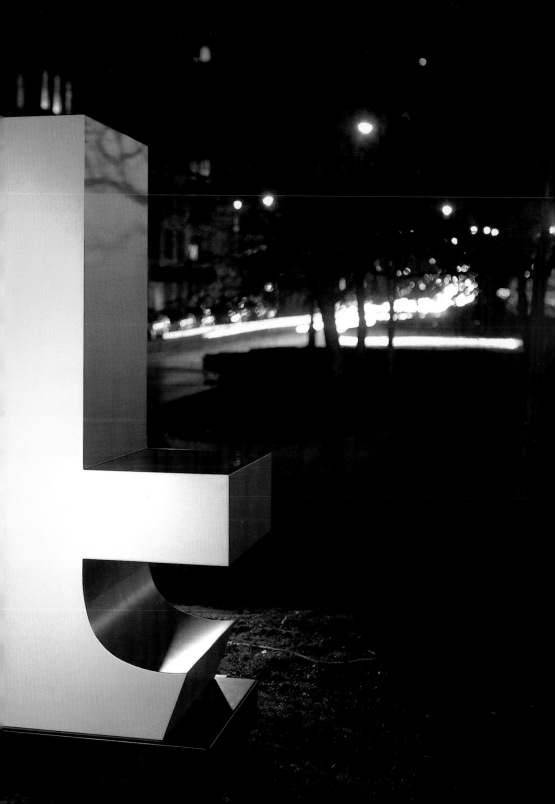

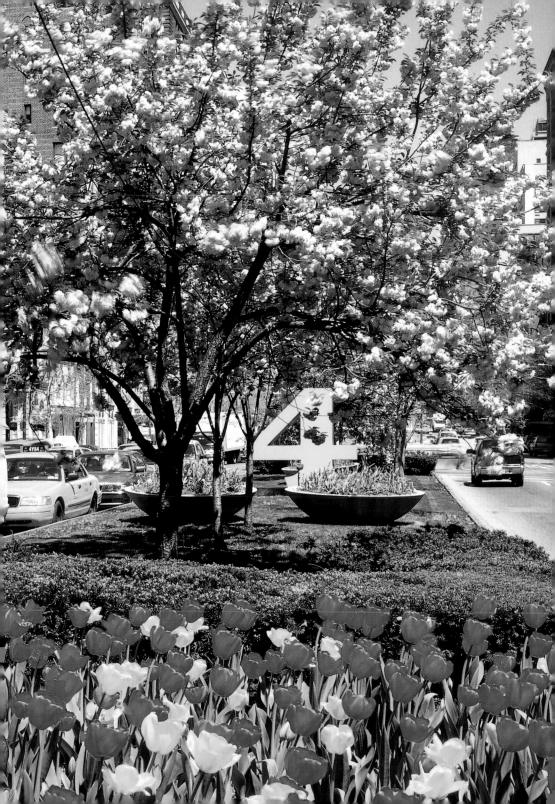

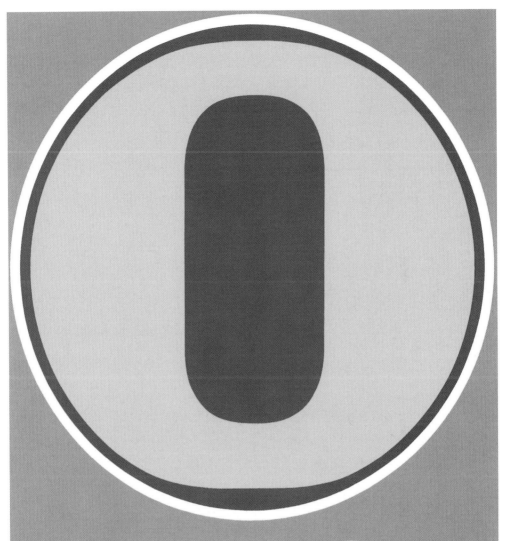

ZERO

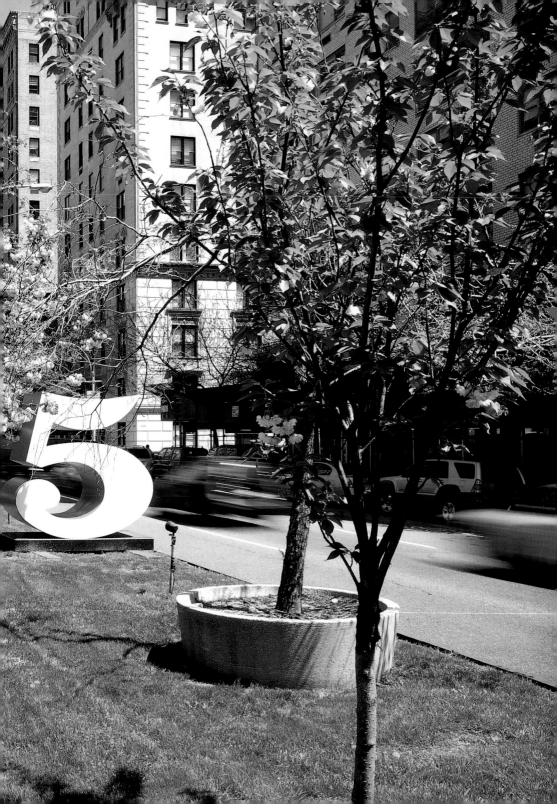

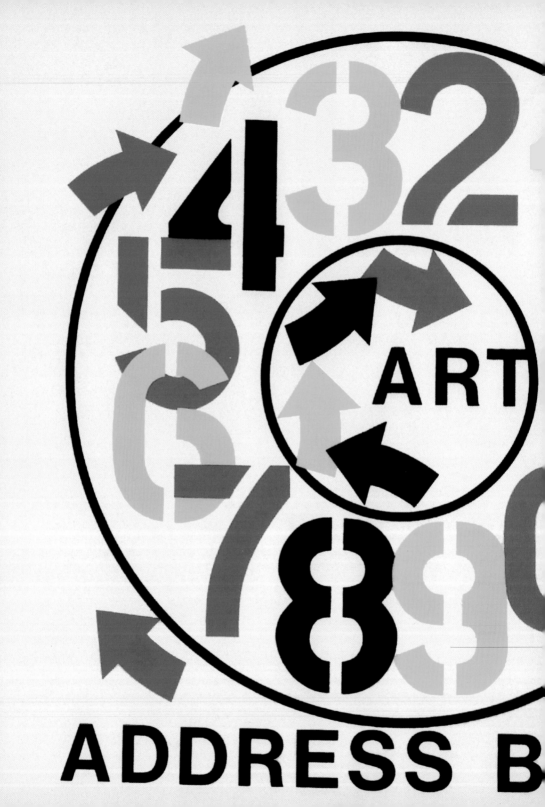

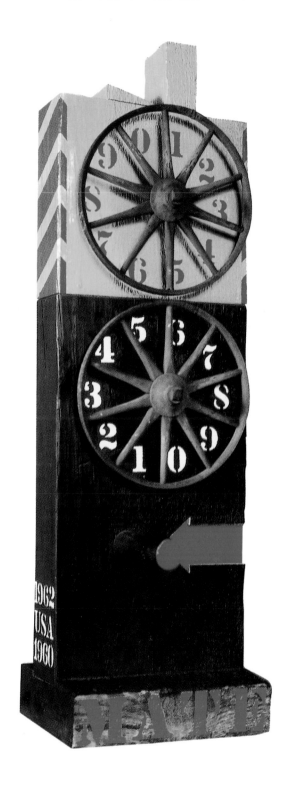

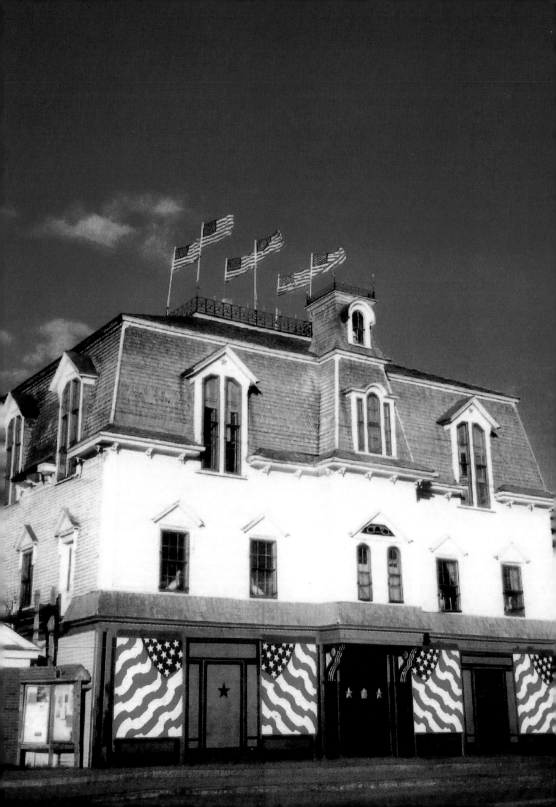

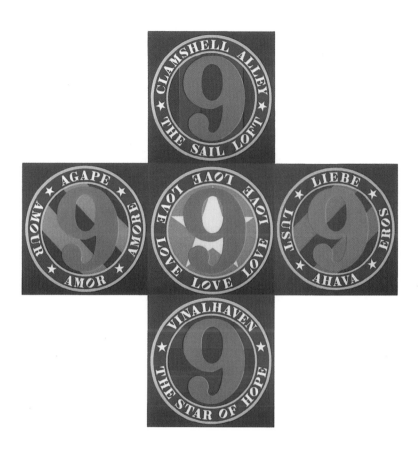

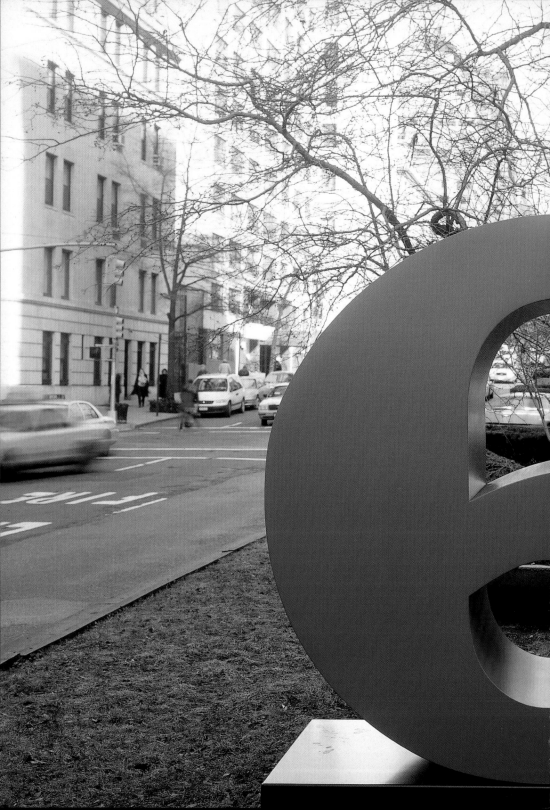

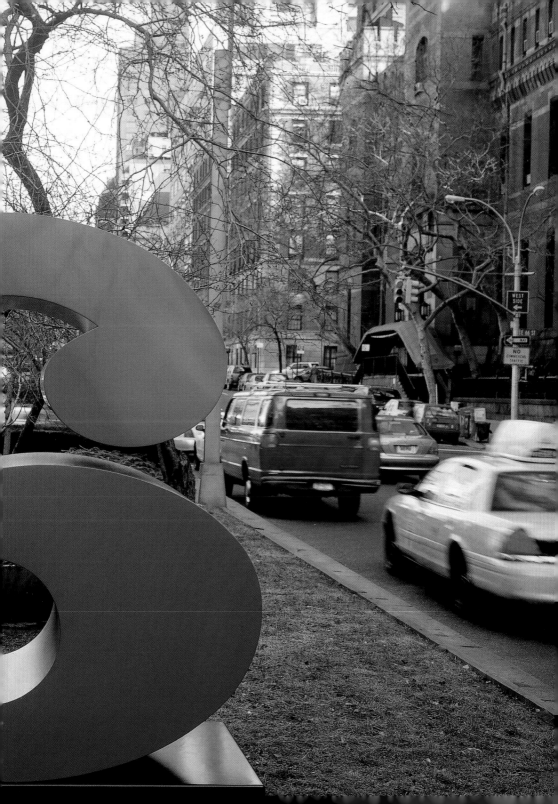

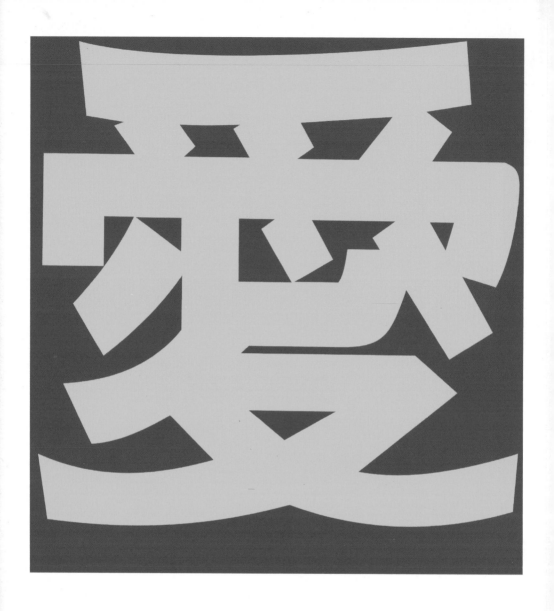

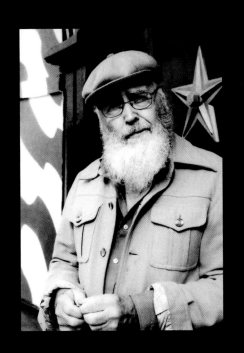

Robert Indiana

The artist in front of his studio on Coenties Slip, 1965.Photo: Abe Dulberg

The artist's journal, dated Thursday, March 2, 1961. © 2003 Morgan Art Foundation, ARS, New York. Courtesy of Paul Kasmin Gallery.
The Triumph of Tira, 1960–61. Oil on canvas, 72 x 60 inches. Sheldon Memorial Art Gallery, University of Nebraska–Lincoln, Nebraska Art Association Collection, Nelle Cochrane Woods Memorial. © 2003 Morgan Art Foundation, ARS, New York. Courtesy of Paul Kasmin Gallery.

One, 1980–2001. Polychrome aluminum on steel base, 78 x 74 x 38 inches. Installation on Park Avenue, New York. February 3–May 4, 2003. © 2003 Morgan Art Foundation, ARS, New York. Courtesy of Paul Kasmin Gallery. Photo: Adam Reich.

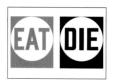

Eat/Die, 1962. Oil on canvas, 2 panels, 72 x 60 inches each. Private Collection, New York. © 2003 Morgan Art Foundation, ARS, New York. Courtesy of Simon Salama-Caro.

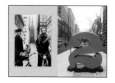

Robert Indiana and Ellsworth Kelly, Wall Street, 1959. Photograph by Hans Namuth. © 1991 Hans Namuth Estate, Collection Center for Creative Photography, University of Arizona. *Two*, 1980–2001. Polychrome aluminum on steel base, 78 x 74 x 38 inches. Installation on Park Avenue, New York. February 3–May 4, 2003. © 2003 Morgan Art Foundation, ARS, New York. Courtesy of Paul Kasmin Gallery. Photo: Adam Reich.

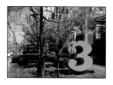

Three, 1980-2001. Polychrome aluminum on steel base, 78 x 74 x 38 inches. Installation on Park Avenue, New York. February 3–May 4, 2003. © 2003 Morgan Art Foundation, ARS, New York. Courtesy of Paul Kasmin Gallery. Photo: Adam Reich.

The Ninth American Dream, 2001. Oil on canvas, 9 panels, 153 x 153 inch diamond. © 2003 Morgan Art Foundation, ARS, New York. Photo: Dennis and Diana Griggs. Courtesy of Paul Kasmin Gallery.
Decade Autoportrait 1969, 1977. Oil on canvas, 72 x 72 inches. Private collection. Courtesy of Pascal de Sarthe, New York. © 2003 Morgan Art Foundation, ARS, New York. Courtesy of Paul Kasmin Gallery.

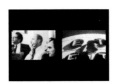

George Segal, Lawrence Alloway, Robert Indiana, and Tom Wesselmann at an art seminar in the cornfields of Ohio, 1966. Photo: Bill Katz.
The artist in front of his electric Eat sign at the New York World's Fair, 1964. Photo: Bill Katz.

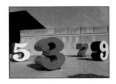

Five, Three, Seven, Nine, 1980–1982. Polychrome aluminum on steel base, 96 x 96 x 48 inches. Collection of the Indianapolis Museum of Art. Gift of Melvin Simon and Associates. © 2003 Morgan Art Foundation, ARS, New York. Courtesy of Paul Kasmin Gallery. Photo: Indianapolis Museum of Art.

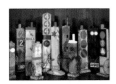

Group of Twelve Constructions. © 2003 Morgan Art Foundation, ARS, New York. Courtesy of Simon Salama-Caro.

Ahava, 1972–1998. Stainless steel, 18 x 18 x 9 inches. Edition 1/8. Private Collection. Courtesy of Jeffrey Loria, New York. © 2003 Morgan Art Foundation, ARS, New York. Courtesy of Paul Kasmin Gallery. Photo: Camerarts.

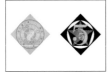

The Metamorphosis of Norma Jean Mortenson, 1967. Oil on canvas, 102 x 102 inches. Collection of Robert L.B. Tobin, New York.Courtesy of the Mc Nay Art Museum and Paul Kasmin Gallery. © 2003 Morgan Art Foundation, ARS, New York. *The Small Diamond Demuth Five*, 1963. Oil on canvas, 51¹/₄ x 51¹/₄ inches. Private Collection, Courtesy of C & M Arts and Simon Salama-Caro. © 2003 Morgan Art Foundation, ARS, New York. Courtesy of Paul Kasmin Gallery.

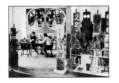

On the Bowery, New York, 1966. Photo: Basil Langton.

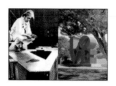

Working on the first monumental LOVE at Lippincott, New Haven, Connecticut, 1970. © 2003 Morgan Art Foundation, ARS, New York. Courtesy of Paul Kasmin Gallery. Photo: Tom Rummler.
LOVE, 1966–1993. Polychrome aluminum, 144 x 144 x 72 inches. Scottsdale, Arizona. © 2003 Morgan Art Foundation, ARS, New York.

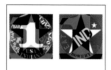

Decade Autoportrait 1961, 1977. Oil on canvas, 72 x 72 inches. R.L.B. Tobin Collection. © 2003 Morgan Art Foundation, ARS, New York. Courtesy of Paul Kasmin Gallery.
Decade Autoportrait 1961, 1971. Oil on canvas, 24 x 24 inches. Private Collection, New York. © 2003 Morgan Art Foundation, ARS, New York. Courtesy of Simon Salama-Caro.

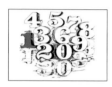

Numbers drawing taken from a statement about the completion of the number "One," the first in a series of numeric sculptures commissioned by Melvin Simon and Associates in 1981. © 2003 Morgan Art Foundation, ARS, New York. Courtesy of Paul Kasmin Gallery.

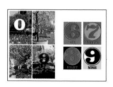

Zero, Seven, Eight, and Nine, 1980–2001. Polychrome aluminum on steel base, 78 x 74 x 38 inches each. Installation on Park Avenue, New York. February 3–May 4, 2003. © 2003 Morgan Art Foundation, ARS, New York. Courtesy of Paul Kasmin Gallery. Photos: Adam Reich. *Numbers*, 1968. Ten serigraphs, $25^1/_2$ x $19^1/_2$ inches. Collection of the artist. © 2003 Morgan Art Foundation, ARS, New York. Indiana-Creeley Numbers Book. Courtesy of Paul Kasmin Gallery.

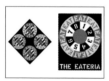

The Beware-Danger American Dream No. Four, 1963. Oil on canvas, four panels, $102^1/_4$ x $102^1/_4$ inches assembled. © 2003 Morgan Art Foundation, ARS, New York. Courtesy of Paul Kasmin Gallery. *The Eateria*, 1962. Oil on canvas, $60^1/_4$ x $47^7/_8$ inches. Hirshhorn Museum and Sculpture Garden, Smithsonian Institution. Gift of Robert H. Hirshhorn, 1966. © 2003 Morgan Art Foundation, ARS, New York. Courtesy of Paul Kasmin Gallery.

The Sweet Mystery, 1960–1962. Oil on canvas, 72 x 60 inches. Private Collection, Courtesy of Simon Salama-Caro, London. © 2003 Morgan Art Foundation, ARS, New York. Courtesy of Paul Kasmin Gallery.
Ginkgo, 2000. Oil on canvas, 60 x 50 inches. © 2003 ARS, New York. Courtesy of Paul Kasmin Gallery. Photo: Dennis and Diana Griggs.

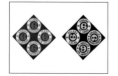

US 66 (States), 2002. Oil on canvas, $101^1/_2$ x $101^1/_2$ inches diamond. Diptych 1 of 2. © 2003 ARS, New York. Courtesy of Paul Kasmin Gallery. Photo: Dennis and Diana Griggs.
US 66 (Cities), 2002. Oil on canvas, $101^1/_2$ x $101^1/_2$ inches diamond. Diptych 2 of 2. © 2003 ARS, New York. Courtesy of Paul Kasmin Gallery. Photo: Dennis and Diana Griggs.

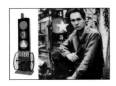

Orb, 1960. Oil, iron wheels, and iron on wood, 62 x 19¹/₂ x 19 inches. Private collection. New York. © 2003 Morgan Art Foundation, ARS, New York. Courtesy of C & M Arts and Simon Salama-Caro.
Robert Indiana in his studio storeroom on Coenties Slip, 1960. Photo: John Ardoin.

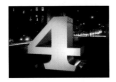

Four, 1980–2001. Polychrome aluminum on steel base, 78 x 74 x 38 inches. Installation on Park Avenue, New York. February 3–May 4, 2003. © 2003 Morgan Art Foundation, ARS, New York. Courtesy of Paul Kasmin Gallery. Photo: Adam Reich.

Four, 1980–2001. Polychrome aluminum on steel base, 78 x 74 x 38 inches. Installation on Park Avenue, New York. February 3–May 4, 2003. © 2003 Morgan Art Foundation, ARS, New York. Courtesy of Paul Kasmin Gallery. Photo: Adam Reich.

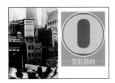

The Denizens of Coenties Slip: Delphine Seyrig and baby Duncan, Robert Indiana, Ellsworth Kelly, Jack Youngerman, and Agnes Martin, 1959. Photograph by Hans Namuth.© 1991 Hans Namuth Estate, Collection Center for Creative Photography, University of Arizona. *Numbers*, 1968. Ten serigraphs, 25¹/₂ x 19¹/₂ inches. Collection of the artist. © 2003 Morgan Art Foundation, ARS, New York. Indiana-Creeley Numbers Book. Courtesy of Paul Kasmin Gallery.

Five, 1980–2001. Polychrome aluminum on steel base, 78 x 74 x 38 inches. Installation on Park Avenue, New York, February 3–May 4, 2003. © 2003 Morgan Art Foundation, ARS, New York. Courtesy of Paul Kasmin Gallery. Photo: Adam Reich.

Artists's Address Book, 8 x 7¹/₂ inches. © 2003 ARS, New York. Courtesy of Paul Kasmin Gallery.
Mate, 1960–62. Wood and mixed media, 41 x 12¹/₂ x 12³/₄ inches. Whitney Museum of American Art, Gift of the Howard and Jean Lipman Foundation, Inc. © 2003 Morgan Art Foundation, ARS, New York. Courtesy of Paul Kasmin Gallery.

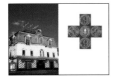

The Star of Hope Lodge. Vinalhaven, Maine, 2002. Courtesy of Paul Kasmin Gallery. Photo: Percy Washington.
The Ninth Love Cross, 2001. Oil on canvas, 108 x 108 inches cross shape, 5 panels at 36 x 36 inches. © 2003 ARS, New York. Courtesy of Paul Kasmin Gallery. Photo: Adam Reich.

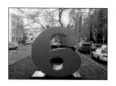

Six, 1980–2001. Polychrome aluminum on steel base, 78 x 74 x 38 inches. Installation on Park Avenue, New York. February 3–May 4, 2003. © 2003 Morgan Art Foundation, ARS, New York. Courtesy of Paul Kasmin Gallery. Photo: Adam Reich.

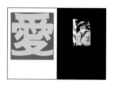

Chinese Love image, taken from a poster made for Robert Indiana's exhibition at the Shanghai Art Museum in 2002. © 2003 Morgan Art Foundation, ARS, New York. Courtesy of Paul Kasmin Gallery.
Portrait of the artist, 2002. Courtesy of Paul Kasmin Gallery. Photo: Percy Washington.

The publisher would like to thank Robert Indiana and the Paul Kasmin Gallery, particularly Paul Kasmin, Allison Martone, and Alissa Wagner, for their invaluable assistance in producing this book. Many thanks also to the photographers Abe Dulberg, Adam Reich, Dennis and Diana Griggs, Bill Katz, Basil Langton, Tom Rummler, Camerarts, and Percy Washington, and the families of John Ardoin and Hans Namuth. Finally, this book could not have been published without the help and co-operation of Simon Salama-Caro, the Morgan Art Foundation, and the Artists Rights Society.